Ballet
Coloring & Activity Book

by Idan Boaz

ISBN-13: 978-1535282598
ISBN-10: 1535282592

Illustration by
atondrilla production

Copyright © 2016 by Idan Boaz

All rights reserved. No part of this book may be used or reproduced in any matter whatsoever without permission in writing from the creator except in the case of brief quotations embodied in critical articles or review.

First edition, 2016

This Book Belongs To

Ever since I could remember, I've really liked being at the ballet studio. Do you like ballet? If so, color this page.

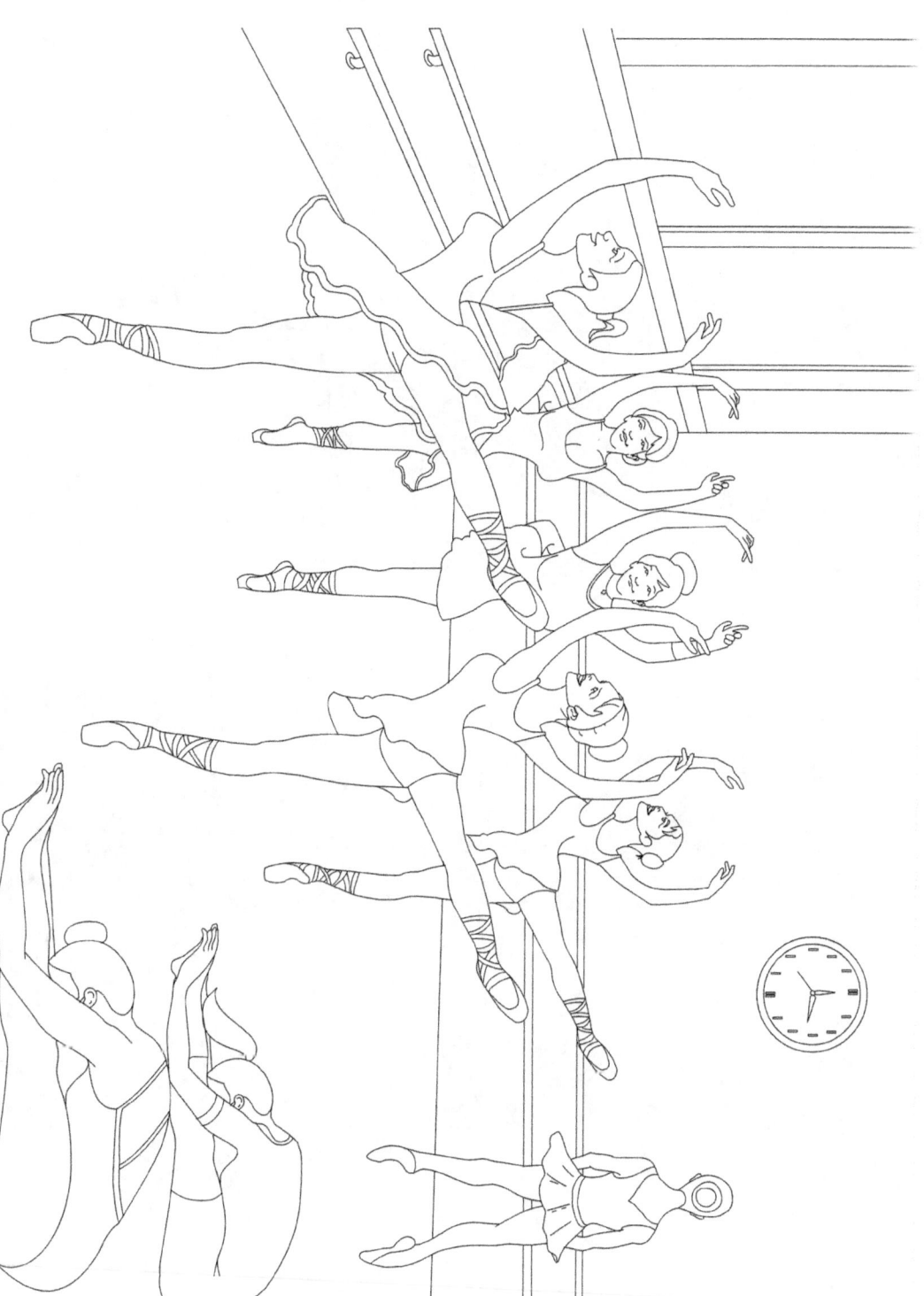

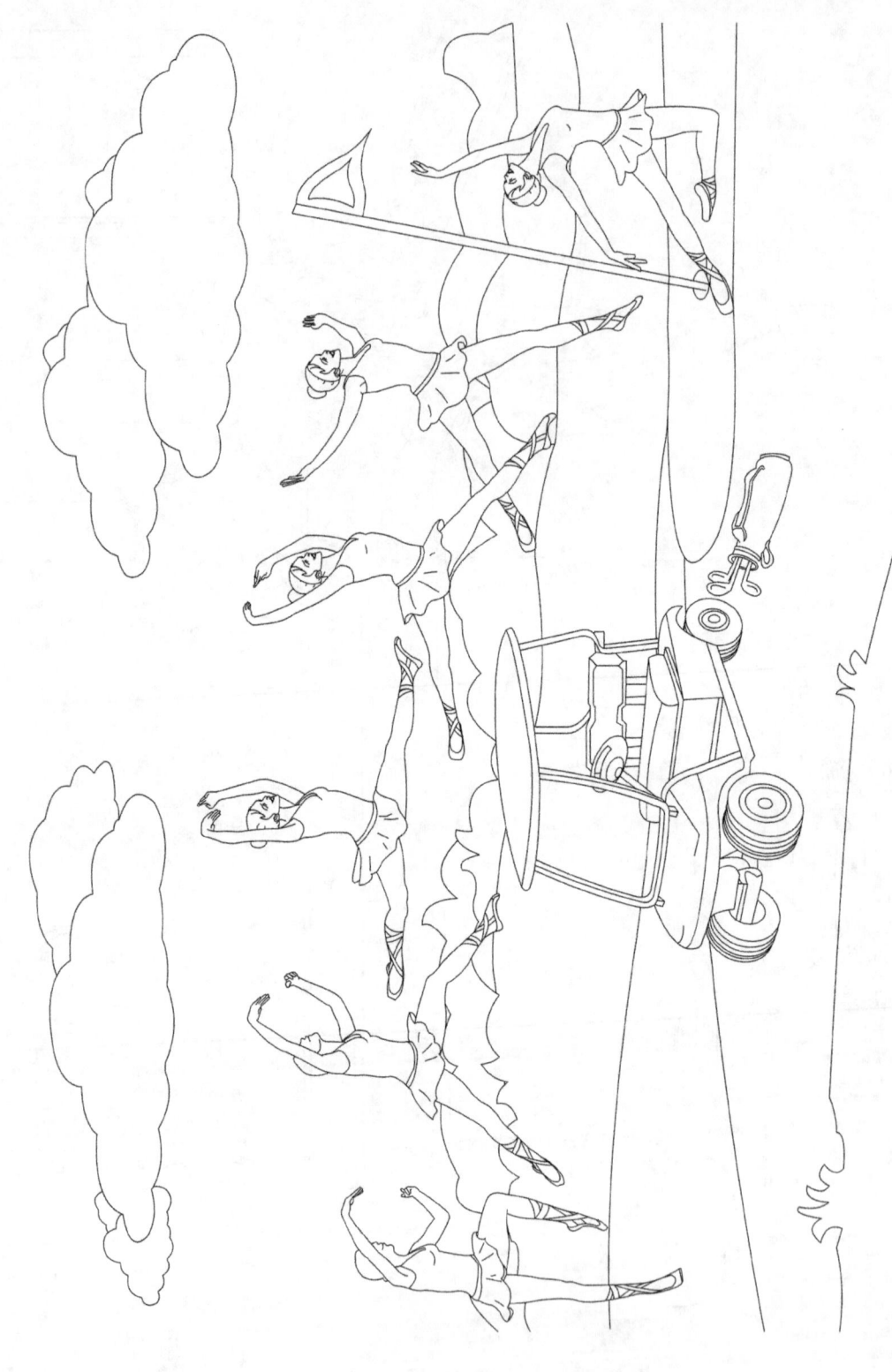

I enjoy dancing on a golf course or any place in the world. Dancing makes me feel good and strong. Pretend to be dancing with me and stretch your arms and legs out long.

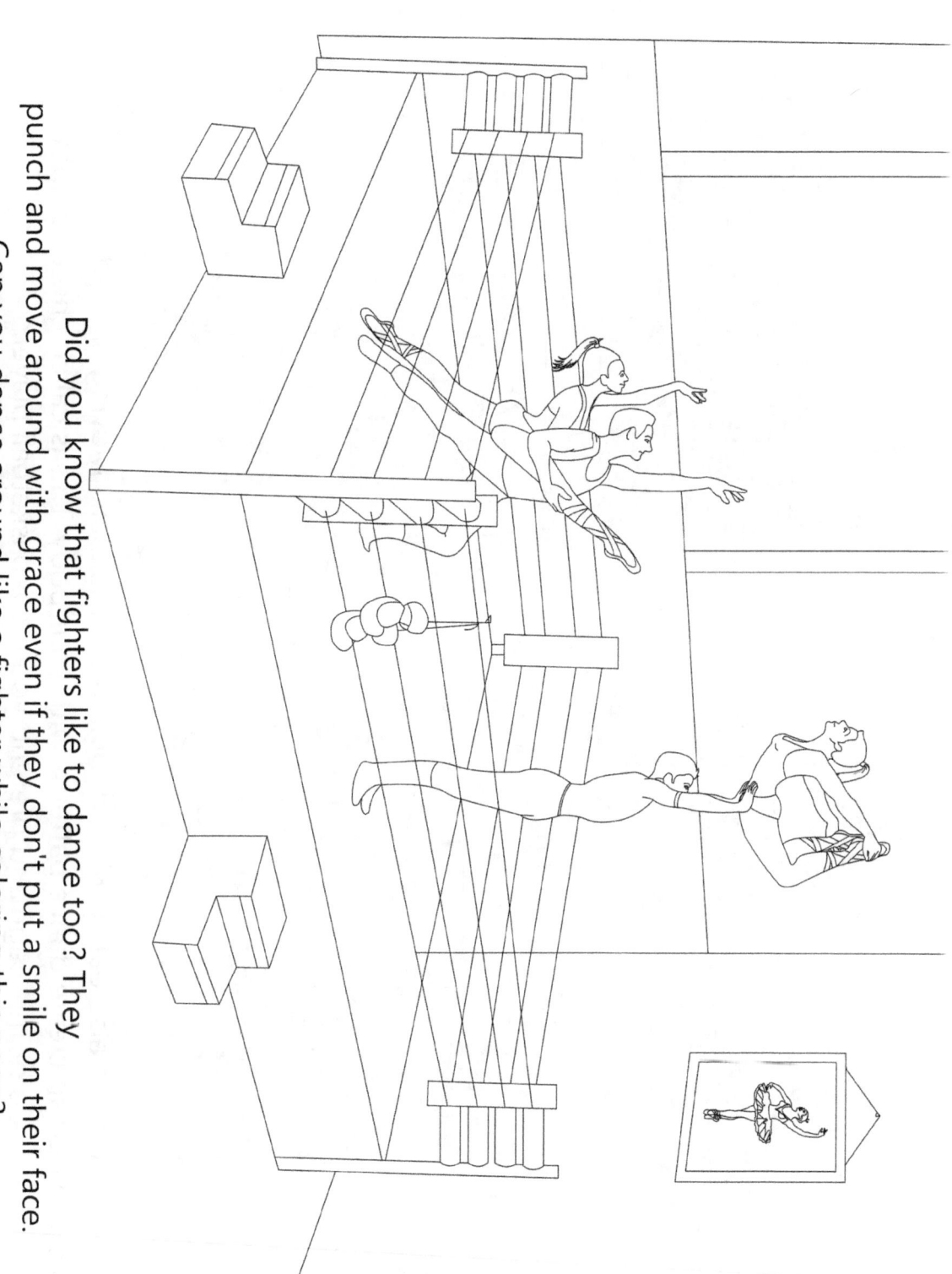

Did you know that fighters like to dance too? They punch and move around with grace even if they don't put a smile on their face. Can you dance around like a fighter while coloring this page?

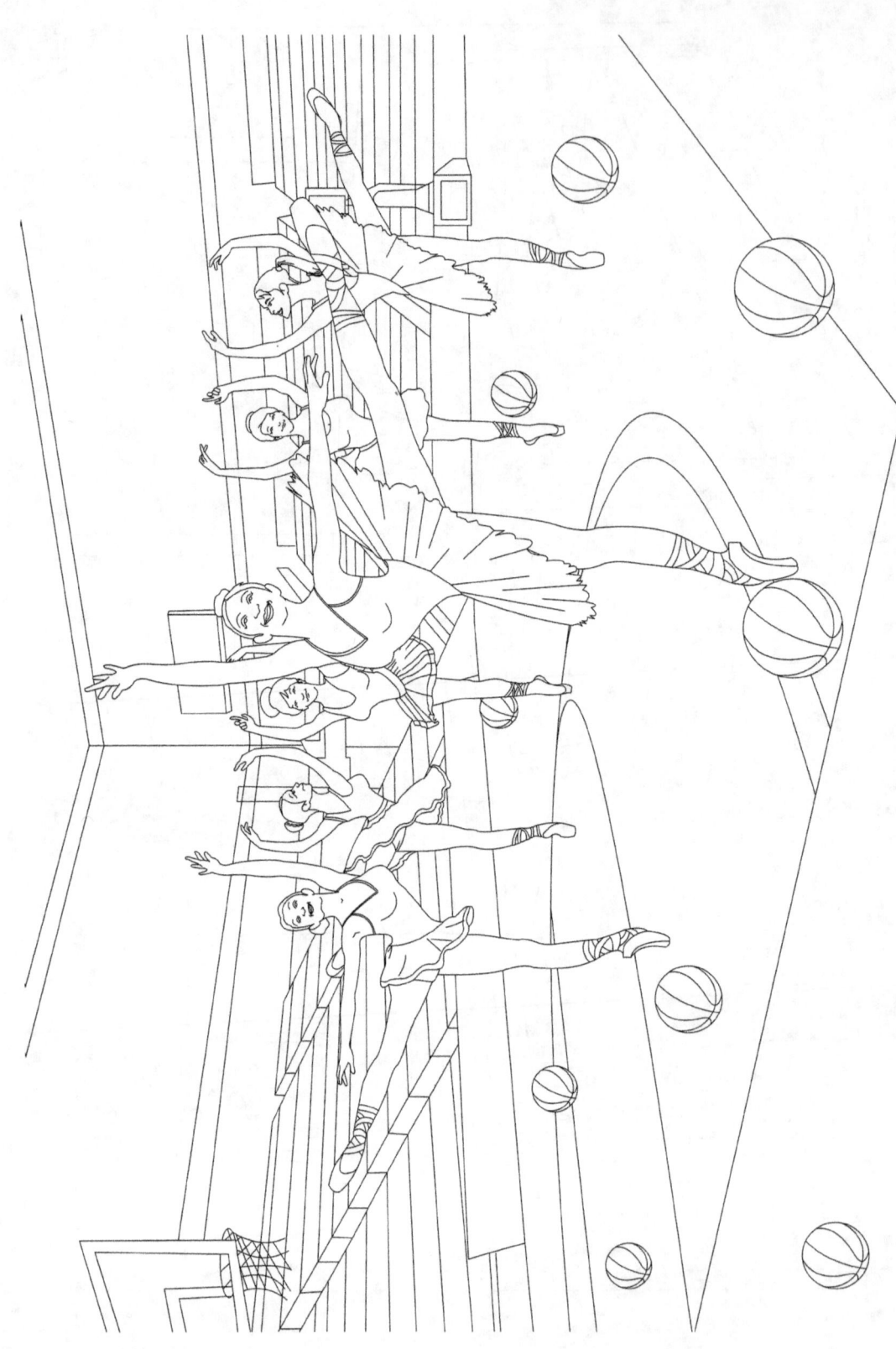

You can also dance while dribbling a basketball. Moving around the court you can create dance patterns with your body. This is called choreography. Color this page and pretend you are a basketball player.

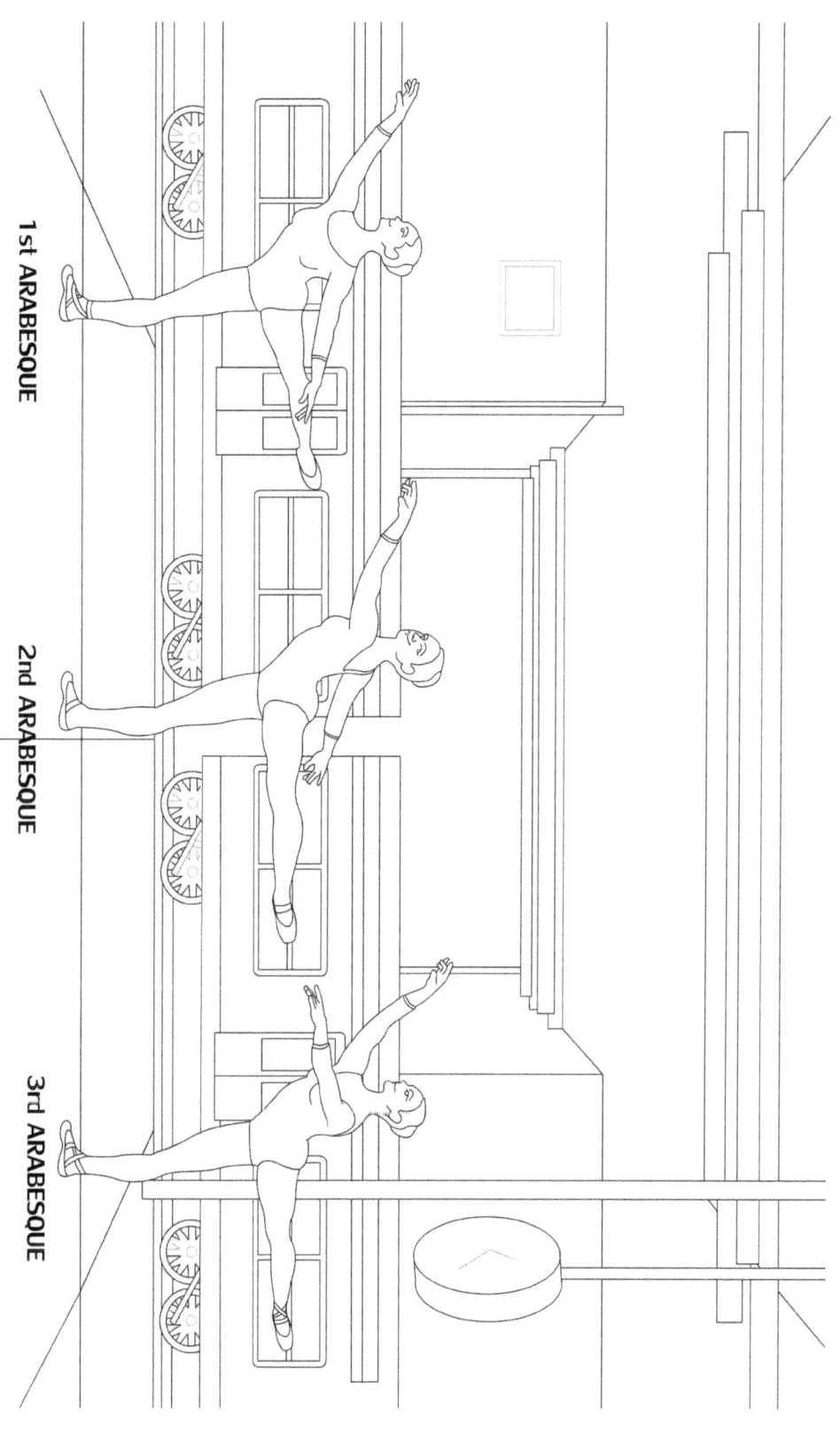

1st ARABESQUE

2nd ARABESQUE

3rd ARABESQUE

Practicing is very important to become a great ballet dancer. Dancing at a train station can be quite a thrill. It's a great place to show off your skills. Make sure to warm-up your body before the train arrives. Smile and don't be shy! Practice your moves while coloring this page.

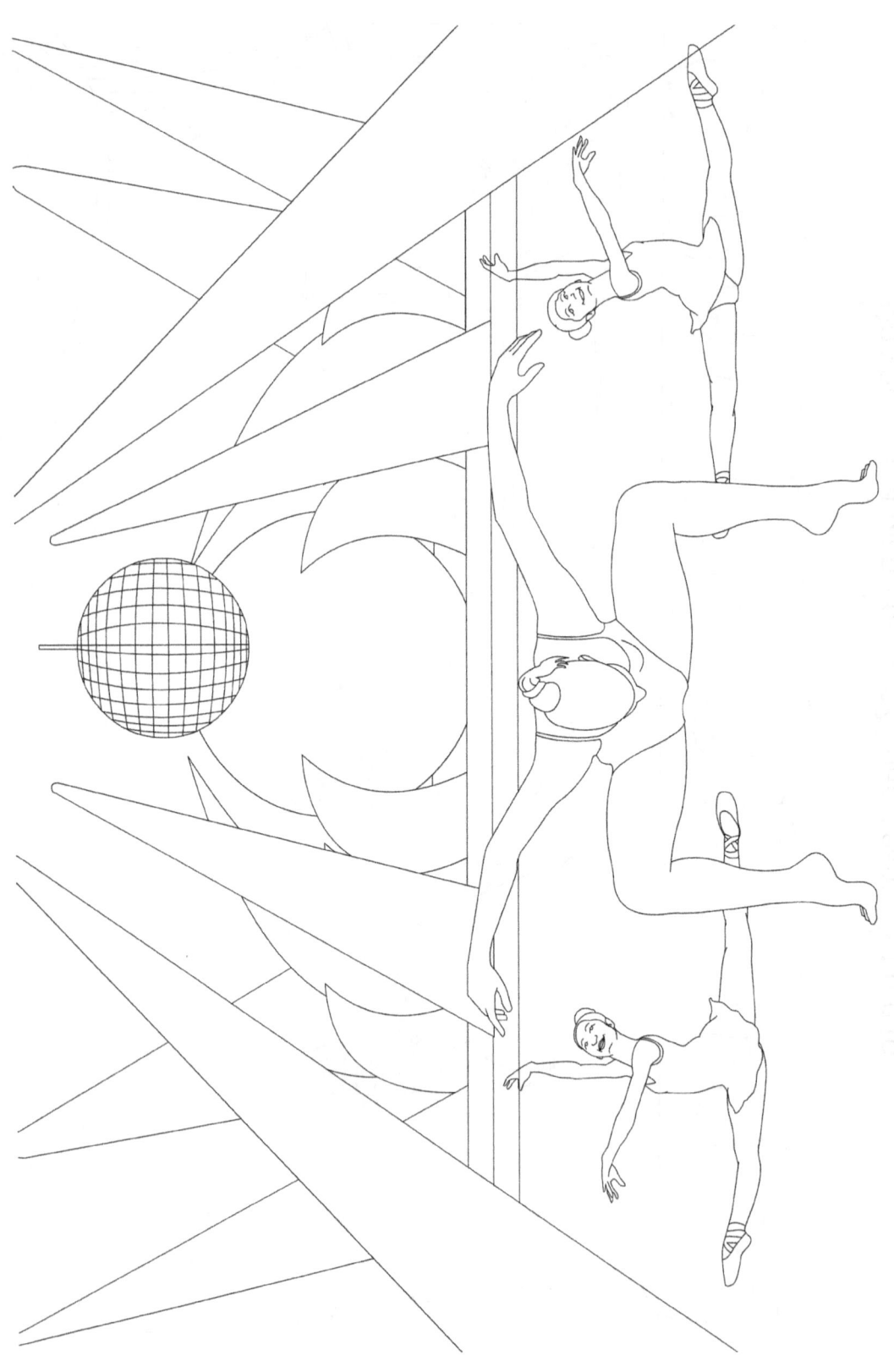

Plie is when you bend your knees. Can you move up and down with ease? Be careful while you work on your flexibility as a dancer. Balance your core and maintain your form. Have fun coloring this page.

Hop and jump around. Practice your ballet moves without touching the ground.

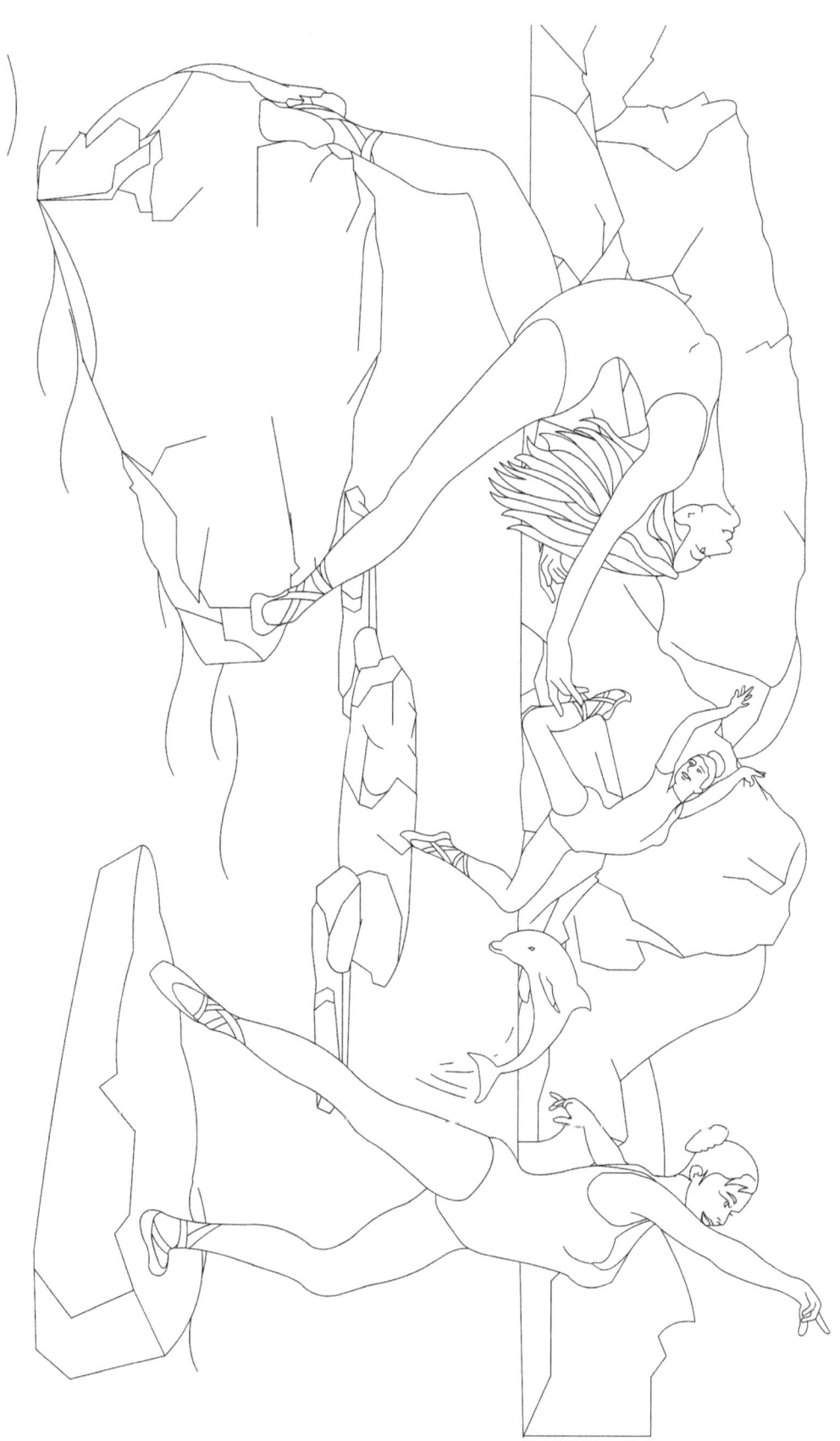

Ballet
Coloring & Activity Book

WORKSHEETS

Oh no! The ballerina forgot her ballet slippers for dance class. Help her get to her slippers before the ballet lesson starts.

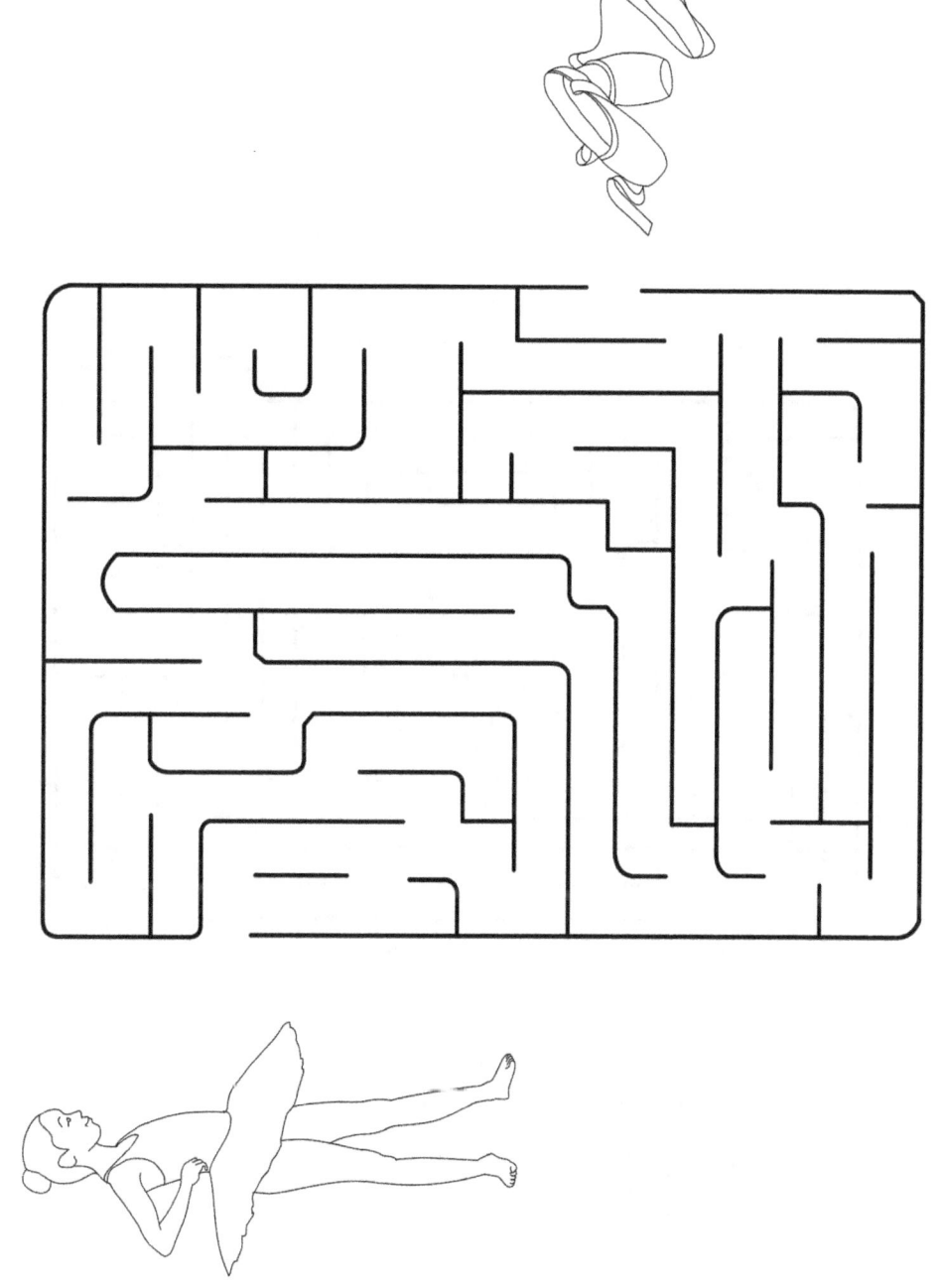

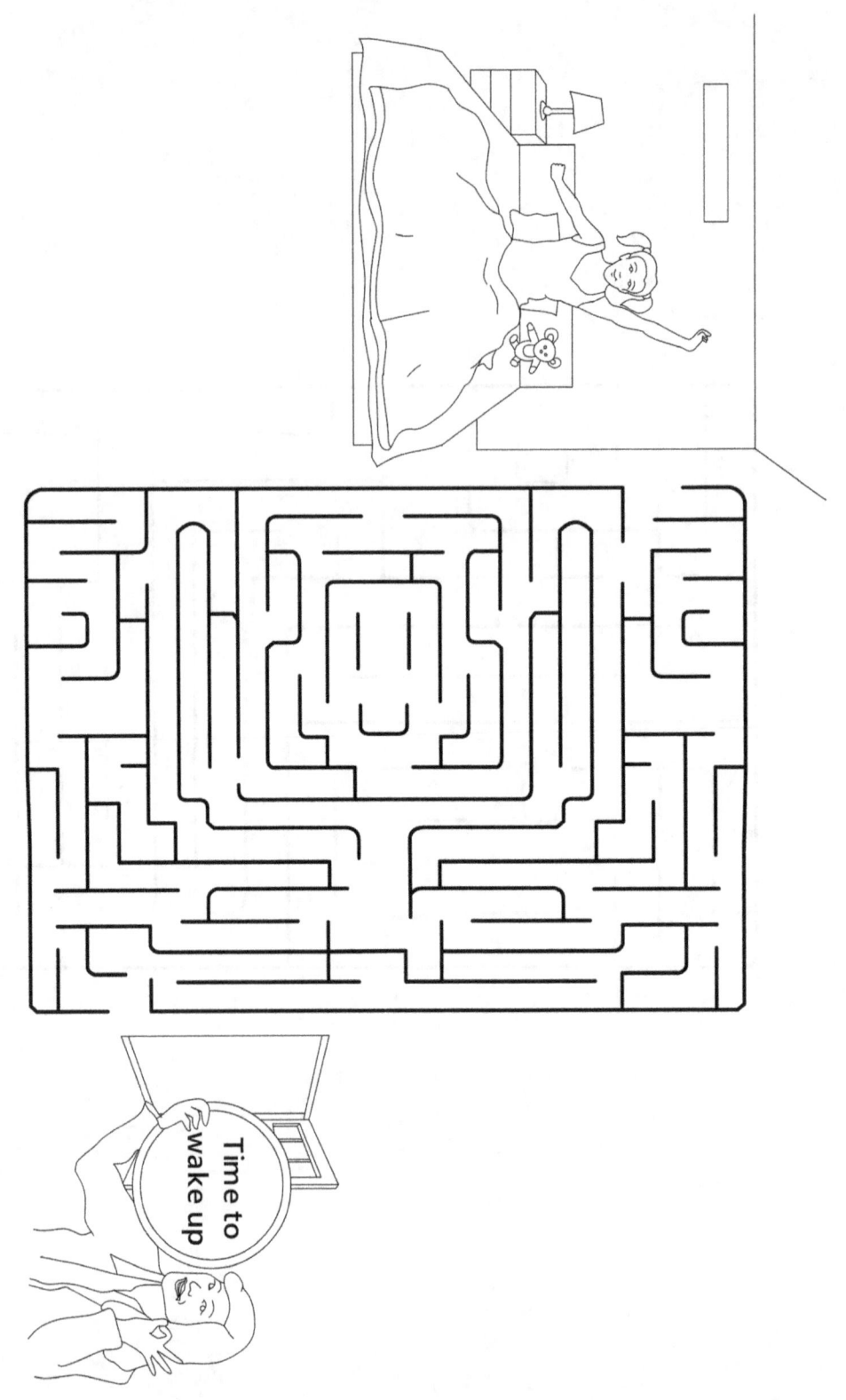

Please help the ballerina wake up in time for her ballet lesson.

Comparison
Match Silhouette to Character

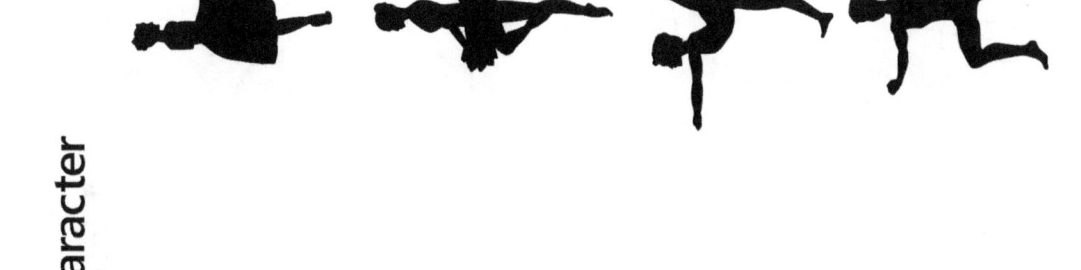

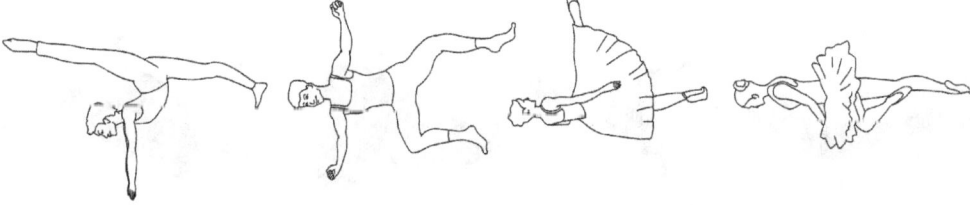

Comparison
Match Silhouette to Character

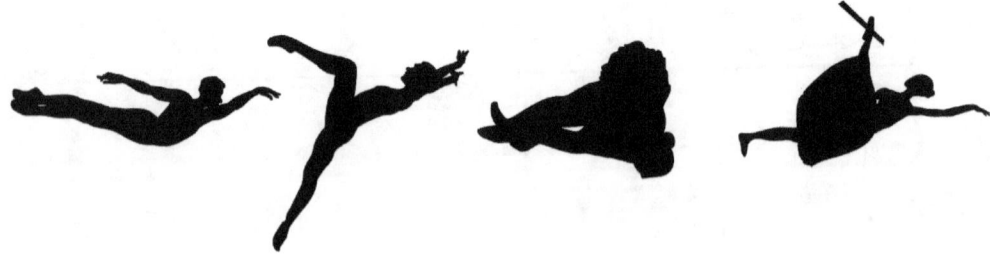

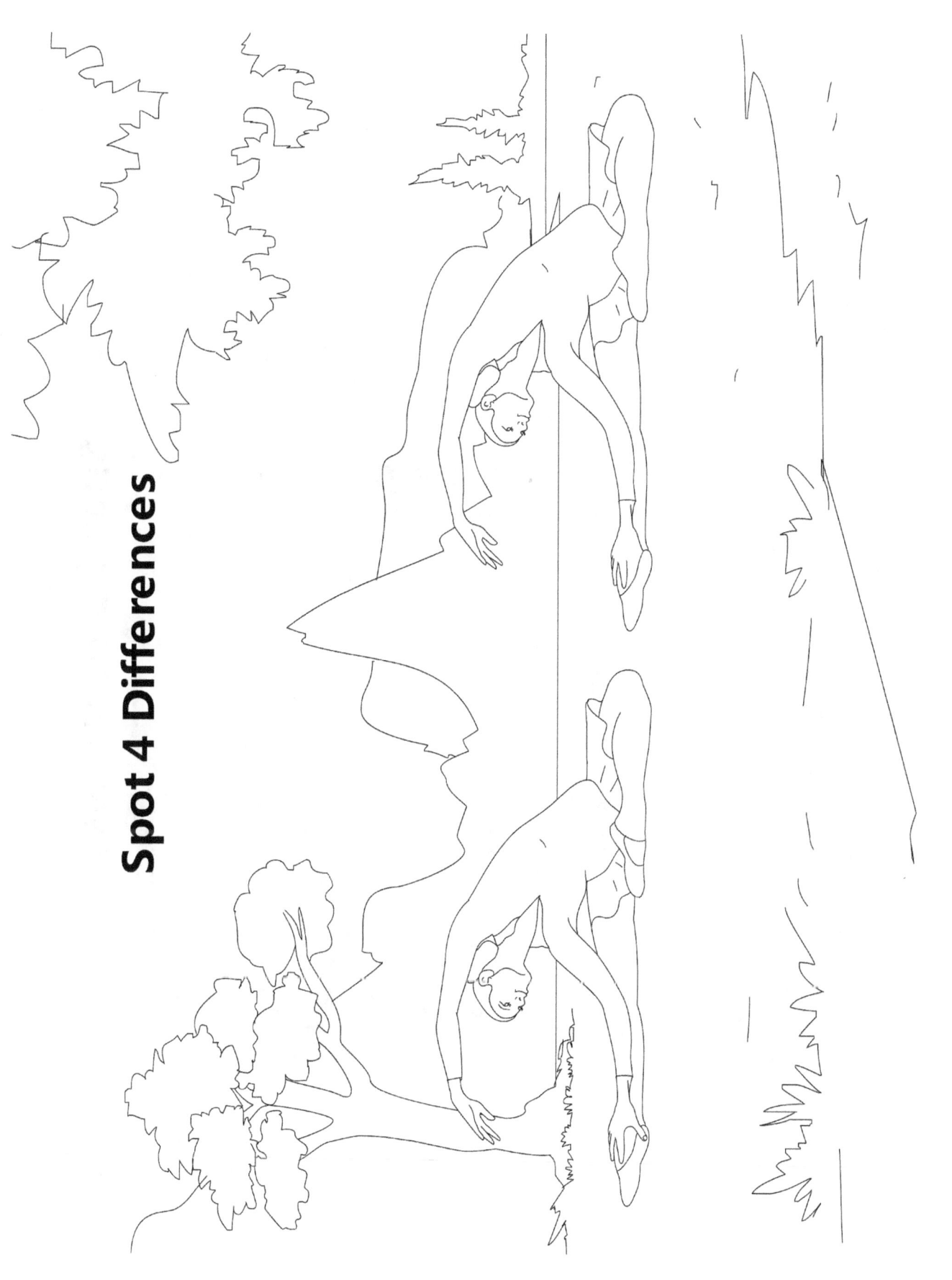

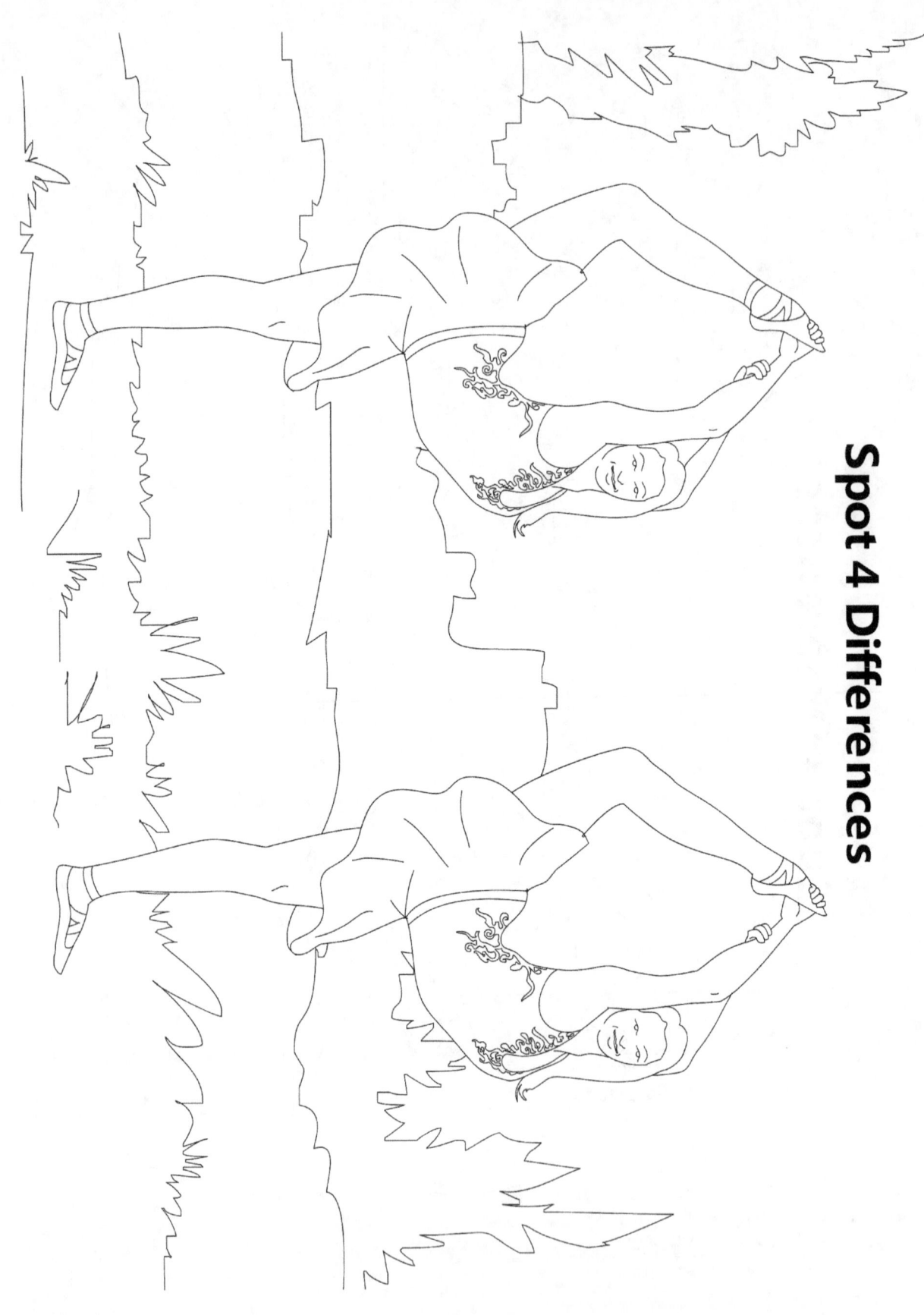

Spot 4 Differences

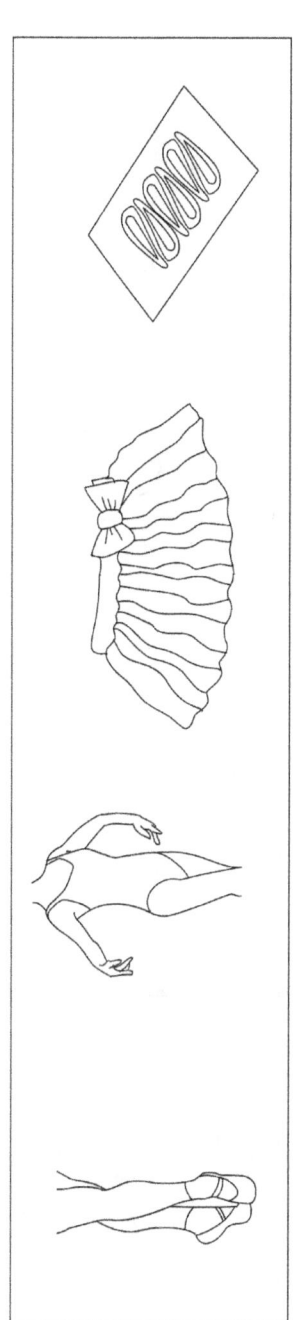

Match Same Objects
Draw a line to the matching Object

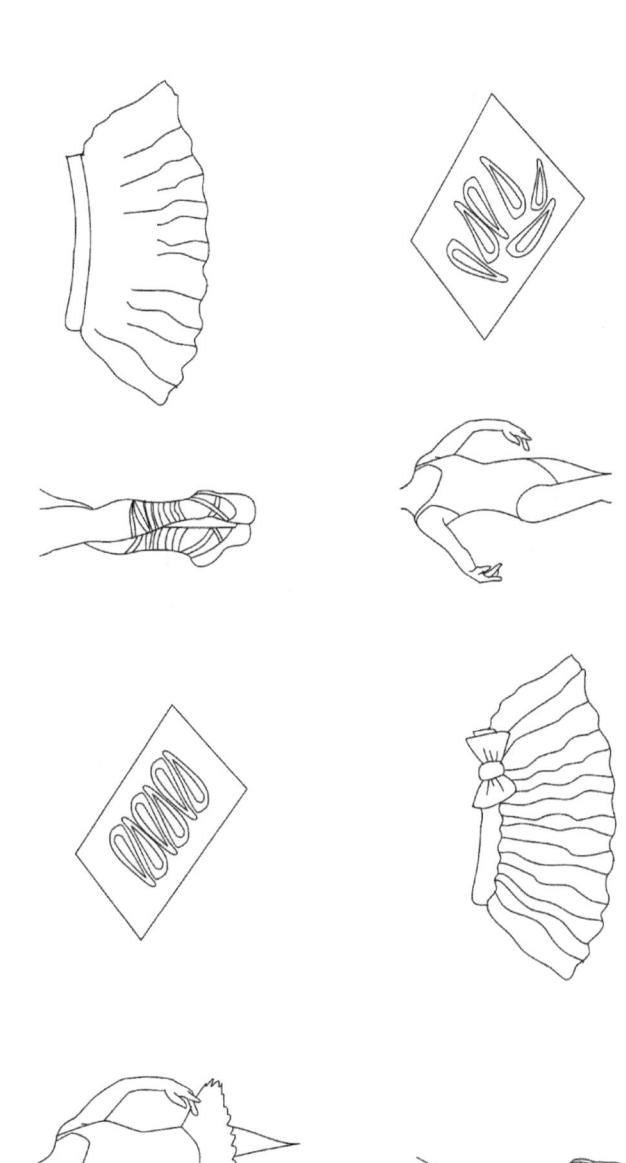

Match Same Objects
Draw a line to the matching Object

Match Same Objects
Draw a line to the matching Object

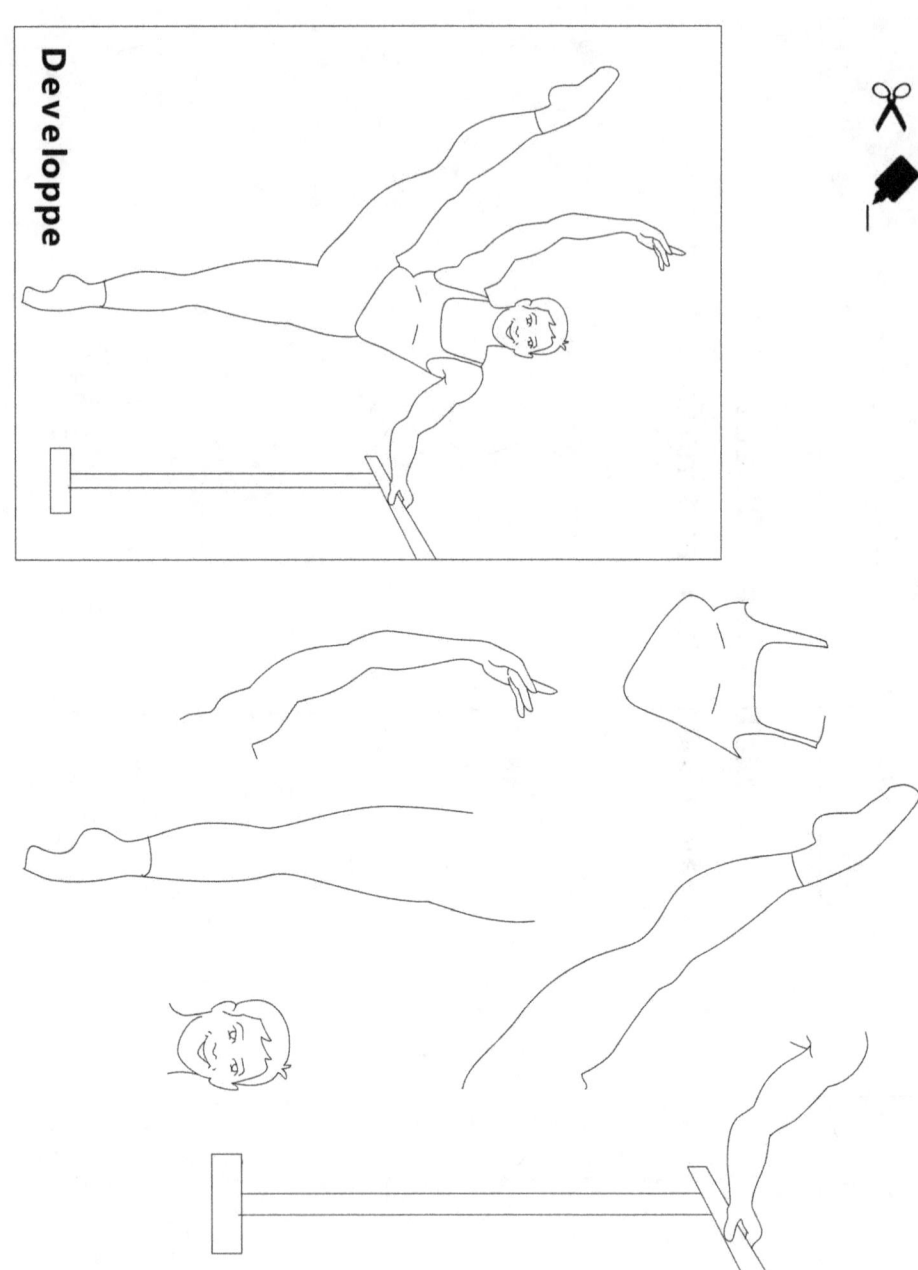

Intentionally Left Blank

Cut Out & Play

1. Color and cut out all parts
1. Arrange parts by order

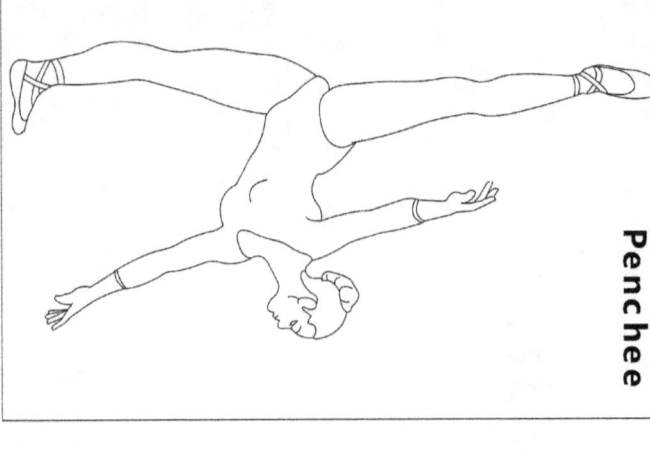

Penchee

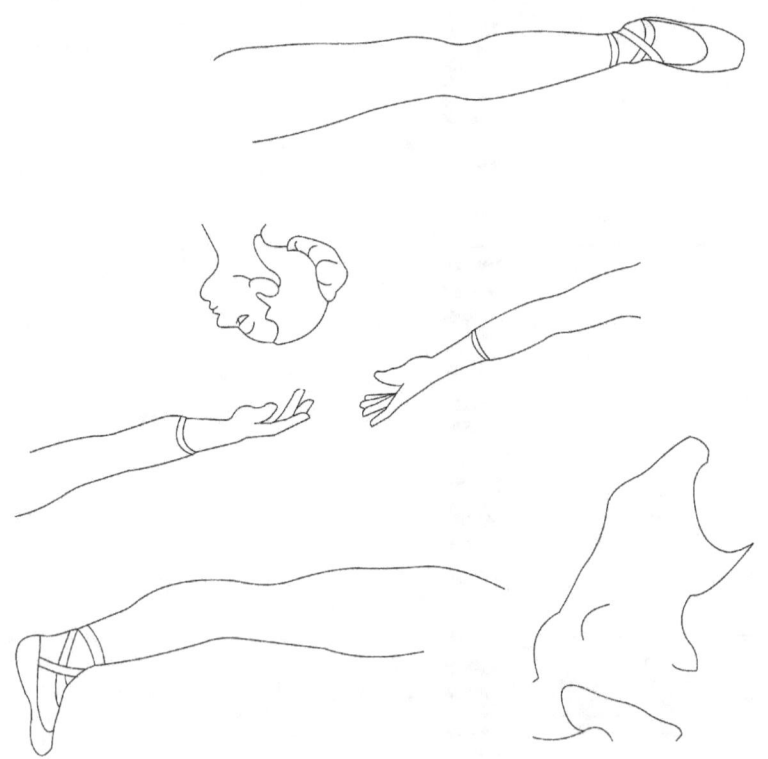

Intentionally Left Blank

Dear Aspiring Ballet Dancer,

Thank you for picking up my book. It has always been my joy to reach out to young dancers who are passionate about ballet. I hope that this book will be with you as you achieve to become a successful dancer.

Hopefully you can leave your thoughts about the book, or suggestions on what you'd like to see in my upcoming books. You can also visit my page on Amazon to check out my other books.

Best of luck,
Idan Boaz

If you have any comments or advice, please share them with me:
info@idanboaz.co.il
www.author.idanboaz.co.il

www.ingramcontent.com/pod-product-compliance
Lightning Source LLC
Chambersburg PA
CBHW080532190526
45169CB00008B/3123